IMAGES
of America

FREMONT COUNTY

Vivian Knappe was born in 1884 and was the daughter of a pioneer family. She attended Drake University in Des Moines, where she took art classes to develop her interest in painting and drawing. She taught school in Hamburg and was married to Harry Wieder. Her lifelong passion for Fremont County history culminated in her drawing of the map shown on this page. Vivian died in 1966.

ON THE COVER: Pictured are county residents hired through the Works Progress Admnistration program building one of the first bridges designed by county engineer Ralph Greenwood. See page 27 for more information. (Courtesy the Fremont County Historical Society photographic collection.)

IMAGES of America
FREMONT COUNTY

Fremont County Historical Society

ARCADIA PUBLISHING

Copyright © 2011 by Fremont County Historical Society
ISBN 978-0-7385-8312-9

Published by Arcadia Publishing
Charleston, South Carolina

Printed in the United States of America

Library of Congress Control Number: 2010939909

For all general information, please contact Arcadia Publishing:
Telephone 843-853-2070
Fax 843-853-0044
E-mail sales@arcadiapublishing.com
For customer service and orders:
Toll-Free 1-888-313-2665

Visit us on the Internet at www.arcadiapublishing.com

To those before us who preserved the county's history and to those in the future who will continue to preserve the past for future generations.

Contents

Acknowledgments		6
Introduction		7
1.	Fremont County: Bountiful Heartland	9
2.	Rural: Land Between the Settlements	21
3.	Hamburg: Cornerstone of Iowa	33
4.	Sidney: Crossroads of the County	47
5.	Tabor: Town with a Story	61
6.	Percival, Thurman: Courageous Pioneers	75
7.	Randolph, Imogene: Prairies and Churches	89
8.	Riverton, Farragut: River Towns	103
9.	Places: There Used to Be a Place Called . . .	117

Acknowledgments

The cochairs for this project are Lona Lewis, president of the Fremont County Historical Society, and Rosie Hall, vice president of the Fremont County Historical Society.

The chapter authors are chapter one, Evelyn Birkby; chapter two, Lona Lewis, with assistance from Erskine Powles; chapter three, Marilyn and Jerry Gude, Rosemary and Howard Spiegel, Linda Hendrickson, Max Maupin, John Field, Nancy Hurst, John Woodward, and Ruth Lauman; chapter four, Marilyn Smith, Bob Crawford, Ruthella Barnard, Bonnie Brown, Louise Holt, Lloyd Mather, and Bill Penn; chapter five, Wanda Ewalt, Kathy Douglass, and Karen Weatherhead; chapter six, Delores Sheldon and Lutie Graham, with assistance from Max Bebout and Howard Ettelman; Sharlyn Trudell, with assistance from Dean Surface; chapter seven, Sherri Perkins, Bonnie Smith, Daisy Malcolm, Janice Bliss, Sandra Gregory, Phyllis Trively, Helen Wilson, Lee Mosier, Becca Castle, Helen Lewis, Janie Brannen, Geraldine Laughlin, and Margaret Laughlin; chapter eight, Lona Lewis with assistance from Sarah Welchans, Margaret Randell, Lois Spargur, Dorothy Allen, Pat Elliott, Emily Bengtson, Janet Burkhiser, and Harold Dinsmore; and chapter nine, Rosie Hall, with assistance from Sharlyn Trudell.

We thank those who provided stories and the numerous town histories that had been done in earlier years by community leaders to celebrate milestones in their respective areas. This was an effort by many.

Pictures in this book are from the Fremont County Historical Society photographic collection and from families that graciously loaned us their treasured photographs.

Thanks go to Sharon Barrett and Evelyn Birkby for proofing and to Ruth Lauman for her technical assistance.

INTRODUCTION

Before any men left a footprint on the land, forces were shaping what would become Fremont County, Iowa. The prominent land feature in the county is the Loess Hills, located no farther than 15 miles east of the Missouri River channel. These hills are the first rise in land beyond the floodplain, something of a "front range" for the county. According to Wikipedia, during the last ice age, glaciers advanced into the area, grinding underlying rock into dust-like glacial "flour." As temperatures warmed, the glaciers retreated, and vast amounts of meltwater and sediment flooded the Missouri River valley. The sediment was deposited on the floodplain, creating huge mudflats. As they dried, the fine-grained silt was picked up by strong prevailing winds. The heavier, coarser silt was deposited close to the Missouri River floodplain, forming vast dune fields. The dune fields (Loess Hills) were eventually stabilized by grass.

The land is affected by a changing climatic zone. To the east, abundant precipitation allows forests to grow. To the west, a drier climate results in expanses of grassy plains. Fremont County is part of a band where there is a change from the forests in eastern Iowa to the grasslands in Nebraska. It manifests itself in this county with grass growing on west-facing slopes and areas of trees on the eastern slopes of the hills. Early descriptions describe prairies with timber along the stream banks. Lastly, the drier climate resulted in frequent fires, which favored the growth of grasses.

The first people to use the land are traced to the Glenwood culture. These prehistoric people used the Platte River for navigation and spent summers in the Loess Hills. Today, there are many identified prehistoric burial sites in the hills. Later, the Lakota Sioux, some of whom had married French Canadian trappers, visited the area via the Platte and Missouri Rivers coming in from the Dakotas. But mostly this was an area that did not have Native Americans as permanent residents until Chief Waubonsie brought his followers to this county.

White men entered the area in the early 1800s. Lewis and Clark write about Fremont County in their journals. We know from these journals that they went up the Nishnabotna River for a few miles. The Missouri River allowed early access into this area from St. Louis and points east. By the 1830s and 1840s, settlers were moving into the area. They found rich farmland. There were rivers and streams such as the Nishnabotna that allowed them to travel inland from the river. Located close to St. Joseph, Missouri, the pioneers could expect the arrival of supplies either via overland hauling or being freighted up the Missouri River. Plentiful creeks provided waterpower for mills to produce flour.

Farms were established in clusters by families that had traveled together. This brought about a need for services, usually the first being a post office that was located in a family home. Sometimes the area would pick up enough population to support a school and perhaps one general store. Church services were important and generally held in a building that all could reach. Only a few of these early settlements went beyond one or two stores. Knox, McPaul, and Bartlett were among the exceptions. Communities like Knox generally faded in the early 1900s.

The next wave of towns developing in the mid-1850s fared better. The three communities of Tabor, Sidney, and Hamburg started at this time and still maintain an importance in the county. Each of these towns started for a reason, and it was not just a matter of a few people living in an area needing services.

Tabor was a result of early settlers looking for a place that was environmentally more friendly than Civil Bend on the Missouri River. They were searching for a place to worship and to also build a college. These men and women made it a mission to assist John Brown in his efforts to help slaves escape to freedom. One dominating theme in the history of Tabor is strong religious beliefs.

Sidney was at the crossroads of the county. It started in the mid-1800s because of the high number of travelers that ventured through the vicinity. Early hotels entertained a president and many superstars from that era. Eventually it became the county seat and remains vital because of county government.

Hamburg started because of its proximity to the Missouri River. The Hamburg landing was the place where river travelers entered the county. Hamburg went on to develop a thriving business economy that is still functioning today. More large businesses are in Hamburg today than elsewhere in the Fremont County.

Lastly, there are six communities that started later in the 19th century and came about because of the railroad or its influence. Percival, Randolph, McPaul, and Farragut were settled because of the railroad. Thurman, while not on the railroad tracks, thrived because of the influence of the rails. Riverton started before the railway arrived, but it was the railroad that kept the town viable for many years. Imogene, while located on the railroad tracks, has a history that was influenced by St. Patrick's Catholic Church and the immigration of the Irish. All of these communities were supported by a thriving agricultural economy. During the early 1900s, Fremont County growers were supplying food products directly to the tables of residents in Council Bluffs, Iowa; Omaha, Nebraska; and St. Joseph, Missouri. Cattle flourished on the grasslands. Crops, especially on the Missouri River bottomland, produced bountiful harvests. The railroad stations shipped thousands of animals and thousands of bushels of grain.

We invite you, the reader, to visit Fremont County via this pictorial history and learn more about its proud past.

One

FREMONT COUNTY
BOUNTIFUL HEARTLAND

The county is in the southwest corner of the state of Iowa. It is bordered on the south by the state of Missouri and on the west by the Missouri River. Standing on the highest bluff in Waubonsie State Park and looking southwestward, Iowa, Missouri, Nebraska, and a corner of Kansas can be seen. The county's very location means there was early exploration, and the area was settled before the central part of Iowa. This place belonged at various times to England, France, and Spain before it was purchased in 1803 by the United States. In their journal, Lewis and Clark wrote about paddling up the two rivers that bisect the county. In the early 1830s, the first community in the county was the French Village, east of what became Hamburg. It was settled by mountain men and fur traders, many of whom had Native American wives. By 1834, Joe Brenard ran a ferry at Hamburg Landing. Augustus Borchers opened a store at the foot of the bluffs, where he served Native Americans and wagon trains. In 1836, Maj. Stephen Cooper, sent as an agriculture agent to the Pawnee Indians, settled at Big Spring. Soon stagecoach lines were running near Cooper's home as passengers and freight were carried between St. Joseph and Kanesville (now Council Bluffs). In 1840, the McKissick brothers settled in an area east of present-day Hamburg. Named after Maj. John C. Fremont—explorer, military expert, and geographical scientist—Fremont County, Iowa, was formed in 1846. For a time, part of the county was in Missouri, then in 1848 surveyors moved the Missouri line south making McKissick's Grove part of Iowa. African Americans came into the county via the Underground Railroad. When M.U. Payne arrived in Hamburg in 1859, he brought with him as free people his African American workmen and women. So it was here, in the center of the United States, where people from many cultures and many lands came to add their energy to help build this beautiful place.

One of the prominent features of the county is the Loess Hills. They create a ruggedly beautiful landscape that bisects all of Fremont County. Along the west edge of the hills is the path that became the Bluff Road of today.

Folsom points have been found in the area confirming that prehistoric humans lived here. Remnants of houses and artifacts indicate these people came up along the river to make their homes. Later tribes traveling through hunted and sometimes spent winters tucked in the shelter of the bluffs. Shown is part of the Polk family's collection.

Southwest Iowa did not have resident Native Americans, but Plains Indians came by to hunt or spend the winter in the warm valleys and hollows of the Loess Hills until 1833, when Chief Waubonsie and his cousin Subchief Shatee of the Potawatomi tribe brought their small groups of followers to this land. Chief Waubonsie, one of the most respected of the elders, settled with 300 people near Tabor. Subchief Shatee settled his group of 150 in Lacy Grove several miles north of Sidney and later lived where Waubonsie State Park is now. Eventually, members of the tribe were moved to reservations in Kansas and Nebraska. Waubonsie left his imprint on the land. The lake north of Thurman was for years called Waubonsie Lake, fed by Waubonsie Creek in the Waubonsie watershed. The Waubonsie State Park is located southwest of Sidney. Chief Waubonsie died in 1848 at the age of 92 and is buried near the Fremont County–Mills County line west of Tabor. Shatee is buried in the Waubonsie State Park.

In 1846, Mormons raised a battalion of 550 men to serve in the Mexican-American War. The map shows their traveling route starting in Kanesville (now Council Bluffs). Accompanied by their families, they came down Bluff Road. After camping in a hollow, several decided to stay, and the town of Thurman resulted. The men reached San Diego in January 1847 after the war was over. Eventually, a number of the soldiers returned to Fremont County to settle in Thurman and McKissick's Grove.

Many covered wagons passed through the county. Some had what was known as a "traveling pantry." Cooks carried spices, sugar, flour, and cooking utensils inside the pantries. They had a breadboard and a rolling pin so the cook could do special baking projects. The historical society museum has one of the few remaining pantries.

Religion played a vital role in the lives of Iowa settlers. In the 1830s, Catholic priests served the people of French Village. By the 1840s, Methodist circuit riders were spreading their message of faith in the county. Many churches were built along the riders' trails from Council Bluffs to St. Joseph. One of those churches was the Knox Methodist Church built in the latter part of the 1880s.

Traveling peddlers were important in the lives of settlers. These merchants, many of them newly arrived immigrants, carried packs of goods on their backs or pulled wagons that carried many of the necessities for daily life among the pioneers. Their assistance made life much easier, especially for the women who lived in primitive conditions. (Pioneer peddler sketch from *Forgotten Pioneers* by Harry Golden, published by the World Publishing Company.)

As the Civil War grew in intensity, young men in Fremont County joined the 15th Iowa Infantry, Company F under the leadership of Capt. James Day. He gathered his green recruits, many fresh off the farm, and marched them across Iowa to Keokuk where they trained for a few weeks. They boarded the steamer *Minnehaha* on the Mississippi River and headed south and east to Pittsburg Landing. On the morning of April 6, 1862, they were disembarking to set up camp and prepare breakfast when all hell broke loose. They were thrown into the Battle of Shiloh, one of the bloodiest encounters of the Civil War. One of Day's swords, the story he wrote of the battle of Shiloh with his Fremont County 15th Infantry, and a number of other related artifacts are in the Fremont County Historical Museum.

In the mid-1800s, a depression created the need to find homes for the children abandoned in cities in the East. From 1853 to 1929, trains, known as orphan trains, were loaded with 300,000 children sent to the Midwest to find new homes. An account from the Hume family describes the process: "In September of 1904 an Orphan Train came to Sidney, Iowa. There were 17 orphans, nine of them were adopted in Fremont County. Three of them were our relatives—our dad Robert J. Hunt—age 4, our aunts Sarah A. Hunt—age 8, and Margaret E. Hunt—age 10. Children from the trains were taken to a court house or church. Our family was given away at the Methodist Church. Each of the three children went to a different family—Robert to the Humes, Sarah to the Maxwells, and Margaret to the Hutchinson family" Sarah and Robert are shown here. Each found a happy home, and many of their descendents now live and work in Fremont County.

The immigrants who came to Fremont County were from many countries, including England, Scotland, Ireland, Switzerland, and Germany. In 1898, Jacob Schnoor traveled from Germany to escape conscription into the army. He came through Ellis Island carrying his possessions and traveled to Chicago to work in the stockyards. There he met a German farmer, Martin Dresher, who had a farm south of Farragut, Iowa. Schnoor returned with Dresher to work as his hired man and eventually, with his salary of $15 a month, saved enough to buy the farm. He married Edith Ackley, of Dutch background, who was a housekeeper for the Dreshers. Jake and Edith started their family, built a fine house and huge barn, and developed Osage Farm. This is one example of a Fremont County immigrant success story.

Sarah C. Cozand was born in 1835. She married Charles R. Taylor in 1854. Sarah and her family came to Fremont County in 1865 and lived on a farm, but it was always Sarah's desire to study medicine. She reached her goal when she graduated from Keokuk Medical College in 1881. She returned to Hamburg to become one of the first female doctors in the area.

Sarah Cozand Taylor built a sanitarium west of Hamburg at the base of the bluffs. She also had her own medical building just south of the Hamburg United Methodist Church. Both structures still stand in 2011. Taylor was diagnosed with cancer in 1904 and died two years later.

During the Great Depression, a Civilian Conservation Corps camp was established in Fremont County. The young men, desperate for work, did much of the trail and shelter building in Waubonsie State Park, constructed roads and bridges, and did reforestation. Working long hours, they sent all but $5 of their $30 monthly pay home to their needy families. The men lived in barracks built just west of Sidney near the rodeo grounds.

The Works Progress Administration (WPA) was a relief measure established in 1935 that offered work to the unemployed through special programs. The Federal Writers' Project, for example, prepared state and regional guidebooks, organized archives, and gave jobs to unemployed artisans. Projects in Fremont County included paintings, such as this one by H. Butler at the county historical museum and the Hamburg post office mural, bridge building, and work on numerous construction projects.

This chapter ends with a story about an unusual item in the Fremont County Historical Society's collection. The Turnbull family of Farragut offered the society Eva Turnbull's collection of soils from around the world. Some members of the historical board thought the society was wrong to accept the gift because it did not pertain solely to Fremont County. Who would want a collection of dirt? But it has become widely viewed. People have come from all parts of the country to see the tiny jars filled with soil from such places as Iwo Jima and near the North Pole. Part of their attraction is the sense that the world is bound to the soil, no matter if it is found in Fremont County or somewhere else.

Two

RURAL
LAND BETWEEN THE SETTLEMENTS

History tends to concentrate on the development of settlements and towns. What becomes forgotten is that without land being settled, there would be no need to create towns. As pioneers arrived in early Fremont County, they found opportunity coupled with challenges. The Missouri River was one of those challenges. It had a great effect on settlement because of frequent flooding, securing supplies, transporting goods to market, and the need to cross to Nebraska. The river, the western boundary of the county, was the early interstate into the area. Arrivals via the river ventured eastward. They found a floodplain that stretched an average of 10 miles. The land was very fertile, which the settlers learned was due to frequent flooding. Looking farther east, they saw in the distance grass-covered hills. When they arrived at the base of the hills, they encountered steep bluffs with only a few openings to allow them to travel eastward. The land was piles of dust that were several hundred feet high with no rock base. The pioneers did not know they were exploring an almost unique land formation found in only one other part of the world—Shaanxi, China. Those settling the Loess Hills soon found that the rich soil was highly erodible. A topography map of Fremont County shows numerous streams and rivers. Settlers first used the waterways but later faced difficulties in crossing them with heavy farm equipment. Beyond the initial bluffs of the Loess Hills, the rest of the county was rolling grassy hills with timber along the streams. Everything needed for prosperous farming was here. Situated between St. Joseph and Council Bluffs, county residents had markets for their crops.

This is possibly what Meriwether Lewis saw July 17, 1804, as he rode out from the Missouri River eastward toward the Bald Pated Hills (now the Loess Hills). This view is from the west bank of the Nishnabotna River, which means "old bed," near where it is thought Lewis and Clark camped July 16 and 17, just south of the Iowa-Missouri border.

In 1859, discussion was held concerning a license for a second ferryboat between Civil Bend and Nebraska City. The general feeling of the incapacity of the present boat to accommodate the traveling public warranted another ferryboat. Judge E.S. Hedges granted a license and the fare was not to exceed 50¢ for a wagon and two horses, mules, or oxen. In July 1859, the new ferryboat *Nebraska City*, manned by William Bebout, arrived carrying two new threshing machines, which were much desired by Iowa farmers.

Crossing the Missouri River presented difficulties. South of Bartlett, the river was shallow, allowing horses and buggies to go across it when there was ice. A pontoon bridge built in 1881 spanned the river from the Iowa side west of Percival to Nebraska City. At that time, it was the largest drawbridge of its kind in the world. James Thomas Stanley, a resident of Percival, was one of the carpenters who helped build the flatboats for the bridge and later collected tolls. Bridge fare was as follows: 40¢ for a double team; 25¢ for a horse and a rider, round-trip; 5¢ for a foot passenger; 10¢ for a loose horse; 5¢ for cattle; and 2¢ for hogs. The pontoon bridge finally succumbed to ice, and the next solution was a bridge.

Pictured here is the railroad bridge crossing the Missouri River. It was built for the Chicago, Burlington and Quincy Railroad (CB&Q). This bridge is also in the drawing above.

23

The 1913 American Automobile Association (AAA) guide shows a road that traverses southern Iowa from Fort Madison to the Missouri River. This road followed today's route of Iowa Highway 2. This section in Fremont County was called the Waubonsie Trail. Dedication ceremonies of the trail were held in July 1911 at Stoney Point, north of Farragut. The prairie surroundings typify the early landscape.

Shady Nook School was located in the Loess Hills north of Sidney. The teacher, Dora Thorne, and Mary D. Thorne, teacher from the Hazel Dell School, hosted a joint contest day in the fall of 1910. One-room schoolhouses, the backbone of education in the county, slowly disappeared, with the last closing its doors in the mid-1950s.

In 1852, slaves were brought across the Missouri River by ferryboat, captained by William Bebout. This passage is thought to be the birth of the Underground Railroad. Dr. Ira Blanchard had built the first frame house in the area and in it prepared quarters to hide escaping slaves. Blanchard hid the runaway slaves behind the fireplace. Upon leaving the Blanchard home, abolitionists would help conduct the slaves through the countryside to Tabor and points north. Several homes on the route to Tabor had similar safe places for runaway slaves to escape detection from bounty hunters sent to retrieve them.

The Missouri River bottom was a mixture of grasslands and cottonwood trees. Cottonwood supplied lumber for the early settlers, especially in townships close to the river such as Benton Township where Percival was located. In the late 1800s, Jonah Parson established a sawmill close to the Missouri River. Mills from this area supplied lumber for the first county courthouse. The lumber had to be floated to the hills for delivery due to high water that year on the river bottom. A large steam engine powered the saw that had sharp blades but no safety features.

Iowa's largest tree, a cottonwood, grew two miles north of Percival. Its circumference was more than 26 feet, and it was more than 80 feet tall. Severe windstorms damaged the tree's branches leading to its death in 1981. The tree was believed to be more than 100 years old.

The Loess Hills presented special problems to bridge builders. The erodible soil and removal of the grasses created "hungry canyons" that grew constantly. The challenge was maintaining a stable creek bank. The answer was a Greenwood Bridge, named for the county engineer in the 1930s who designed it. There were two parts to the bridge: the structure that stabilized the bank and the spillway that kept the water from cutting deeper canyons. The workers, picked up by bus each morning, were county residents who were hired through the Works Progress Administration program. Many Greenwood bridges still stand today and have had an added benefit of stopping soil erosion.

This photograph shows proof of why a Greenwood Bridge was needed. As creek banks eroded, the bridges had to be longer. Eventually the long planks could not support heavy machinery like this thresher.

27

The Baylor family homestead is along the bluffs south of Thurman. Advanced preparation for the barn, built in the 1890s, made for a quick barn raising. Individual pieces of lumber were shipped to McPaul by railroad, then hauled by wagons to the location south of Thurman where bents were laid out on the ground, tenons fitted, and oak pegs securely driven. Mortised connections held the barn together, with peg nails being used only to secure the siding and roof. The feeding floor could accommodate 20 horses, and the granary and mow stored needed hay.

Farmers line up, coming to the aid of a neighbor who had become ill or was injured. Farmers continue this practice of bringing in the harvest for friends today.

High in the Loess Hills bluffs, apples and fruit were protected from late freezes that destroy tender blossoms. This led to many orchards in the county. One that endures is the Mincer orchard, which was started in 1890 by Charles Taylor and is still operated by the family today. Grandson C.E. Mincer took over the operation in the early 1900s. In March 1910, the apple blossoms gave hope of a good season, but on April 17 a killing frost ended those hopes, destroying every apple crop in the state of Iowa and throughout the Midwest—except the Mincer orchard. C.E. Mincer had researched methods to protect his crop and was using 1,000 smudge pots. Later, he spoke at meetings throughout the country about his method. It changed how orchards protect their fruit crops. (Courtesy Marty Mincer.)

Floods were part of the natural cycle for this area. The difficulty arose as farming and settlements tried to survive with frequent destruction of homes and disruption of the growing season. In 1943, a flood of monumental proportions led to water containment using dams built upstream in the Dakotas and levees built along the banks. Building was going on but not completed when the flood of 1952 affected the entire Missouri River Basin. In Fremont County, towns on the bottom became lakes with water from the river to the base of the Loess Hills. The above picture is Bartlett, and the picture below is Hamburg. (Flood Pictorial, Missouri River 1952, Warner Enterprises, Inc.)

In 1849, when Alfred Rich Bobbitt was 17, he and his parents came from Indiana to settle in Iowa. He married Sarah Pugh in 1855, and they moved to a farm four miles west of Sidney in the Knox area. The Bobbitts had 10 children, which included a set of triplets, one of whom died in infancy. The bluffs in the background show the grassy slopes. A large smokehouse in the background on the right side also served as a temporary home when the original wooden house burned. In 1872, the home in the picture was built using bricks made on the farm. Bricks from the farm were also donated to build the Cumberland Presbyterian Church located nearby. Eleven caves were carved into the bluffs to store the Bobbitts' food. Bobbitt recognized that there was an interest in wild game, especially since it was virtually disappearing, so he opened a wild game park for everyone's enjoyment. Today, in a county overrun by deer, this is a great irony.

The size of this woodpile, which extends beyond the camera's view on the left side, indicates the amount of wood needed by the M.B. Holsclaw family, who lived northwest of Percival, for a long, cold winter in 1915. Teenage daughters Alta (left) and Alene climbed log steps to reach the top. Wood cut from the nearby timber was the main source of fuel for a kitchen range and a potbellied stove in the living area.

Here is a rural homestead located in the rolling hills of the county. Note the five men standing in the forefront. It took many workers to operate a farm with the equipment that was available at the time this picture was taken in the early 1900s

Three

HAMBURG
CORNERSTONE OF IOWA

Fred W. Hill, editor and publisher of the *Hamburg Reporter* for 40 years, and W.T. Davidson, editor and publisher of the *Hamburg Republican*, wrote in 1920 this introduction to their book, *Hamburg, The Home City*, which included photographs by the Lorimor Studio: "Down where Iowa, Missouri and Nebraska meet, where the singular bluff (Loess Hills) attains its greatest height and beauty and stands back abruptly to permit the valley of the Nishnabotna, that which Bayard Taylor said there was none more beautiful, to merge with the great flood-plain valley of the Missouri, there, nestled along the foot of the protecting bluff, lies Hamburg. When Hamburg began its history the Missouri River was the only commercial highway. But now two railroads stop ten passenger trains and numerous freights there daily. The doors of seven hotels stand ajar to the weary traveler. The visitor to Hamburg finds two flouring mills with a capacity for making two hundred barrels daily of the staff of life, four general merchandise emporiums for supplying the temporal needs of the community, two canning factories preserving the perishable crops of summer till the winter season, nine churches, two newspapers, excellent public schools and three banks ministering to and nurturing the spiritual, intellectual and commercial life. Good markets and shopping facilities make Hamburg the hub in a large wheel of commercial activity. Surrounded by farms unsurpassed in richness of soil and orchards of fruit unequalled in flavor and exceeded by but few in yield, with fatted cattle on every hand that are annually selected for the choicest markets of the American metropolis, with homes of beautiful exterior and more beautiful with domestic felicity within."

Many things have changed since 1920, but with a glad hand extending to the stranger, Hamburg is a good city in which to stop; it is a better city in which to stay.

Only 17 years after the town of Hamburg was surveyed, unplowed prairie, covered with wild grasses, had given way to this view in 1875. The progress of the town was provided a great impetus when, on December 30, 1867, the Council Bluffs and St. Joseph Railroad was completed and in 1870 when a branch of the Burlington and Missouri River Railroad was built.

Hamburg is situated on the west side of the Nishnabotna River, three or four miles above its junction with the Missouri. It is near the southwest corner of Fremont County, where the "Nishna" breaks through the long line of bluffs that extends irregularly above and below. Nature has lavished some of its most beautiful touches upon the Loess Hills.

James Bordeaux and his Native American wife, Huntkalutawin, were the parents of Louisa Bordeaux, who married Clement Lamoureaux. Clement and Louisa settled in French Village, a collection of Canadian trappers and traders who came to the Hamburg area in the 1830s to trade their furs with the Indians. James Bordeaux became an important figure in the history of the Old West. From 1866 to 1870, he sent all his children "back East" to Hamburg to receive their education.

The pergola at the top of the bluff on the Loess Hills was a popular place where young couples enjoyed climbing the steps that led to it. This view in 1917 shows flooding that resulted from living near confluence of the Nishnabotna and the Missouri Rivers.

The four-story Hamburg House was built around 1867 by A.J. Edwards. The dining room was on the first floor and was also used for dancing. The basement was fitted as a saloon and was presided over by Col. Bill Davis, later county sheriff and state representative. After the hotel's destruction by fire in 1881, the first Julien Hotel replaced it, but in 1897 it also burned to the ground.

Dr. James M. Lovelady and Dr. Cyrus E. Hoover operated a sanitarium and hospital until 1900. Another pioneer doctor was Sarah Taylor, who built a small hospital in Hamburg and operated it for more than 20 years. Her office and home was just east of the post office and is still standing. Taylor possessed the first X-ray machine in southwest Iowa.

Willow Slough was the outlet for surface water in Fremont County from Waubonsie, Plum, Horse, Possum, and Cooper Creeks. In the fall of 1908, this bridge on Main Street was removed and replaced with a fill costing $700. But the floods kept occurring. The Omaha District US Army Corps of Engineers, in the late 1980s and 1990s, spent several million dollars addressing this persistent problem.

It was in 1897 that Crosby "Doc" Stoner purchased the drug business from A.G. Bartlett and established the C. Stoner Company. Upon Stoner's death in 1907, Art Simons purchased a one-third interest in the business and operated it under the name Stoner-Simons until 1912 when Ralph Stoner graduated as a pharmacist and came home to take up the family business. It has been known as the Stoner Drug Company since that time.

William E.L. Bunn's mural *Festival at Hamburg* was a Work Projects Administration Federal Art Project for the Hamburg Post Office and was installed on July 17, 1941. With expansion of the present post office, it was discovered that the alkaline content of the plaster had rotted the canvas beyond repair. This view is a replica of the original painting by Jim Zuck.

The McKissick Opera House seated about 500. Comedy, drama, and musical performances drew full-house audiences from the 1880s through the 1920s. Many early movie stars "trod the boards" in opera houses and theaters before they obtained fame. The featured vaudeville performers on this February 17, 1894, program were Bruns and Nina.

This building, located one mile south of town on the gravel road that straddles the Iowa-Missouri state line, was quite active as an amusement spot before World War I. It was known as the "Line House." It is said that persons pursued by the sheriff of Fremont County would take refuge on the Missouri side of the house, and those fleeing Missouri authorities would scurry to the Iowa portion of the building.

Among early enterprises, the Hamburg Brewery and Bottling Works was established in 1867 by Philip, Peter, and Louis Nies under the firm name Philip Nies & Bro. When local option was adopted in Iowa, the brewery was discontinued. The bottling works stood the tests of time until 1968.

Hamburg had several livery stables until they faded out with the coming of the automobile. F.A. Jones operated this one for many years. There was also the Palace Feed Yard, built after the hitching racks on Main Street were torn down. A customer could drive a team into a stall without unhitching it. A block of hay was furnished, and the customer could bring his or her corn and leave the team all day for a dime.

For years, Hamburg supported two flouring mills—both powered by steam—that ground flour that was sold over a large area. The better known of the two was Eagle Roller Mills, owned and operated by H.R. Grape, a pioneer of the community. This view is of Nishna Valley Milling in 1910, another big institution for the manufacture of high-patent flour.

George Chandler and George Bartlett operated this implement house for a few years around 1900. W.B. Houts, C.W. Davey, J.G. Woolsey, Charles W. Baker, Clifford Good, and Orville Athen were among those who also sold implements including corn shellers, buggies, windmills, spring wagons, McCormick harvesting machines, and John Deere plows.

In the early 1880s, a plow factory was built and operated by William Hanson and John Christian. It manufactured farm implements, especially the "Hamburg daisy tongueless cultivator," of which 800 were built in 1883, while a large factory in Illinois turned out several thousand of the cultivators on royalty. Discrimination in freight rates and other disadvantages rendered the enterprise unprofitable. The factory was destroyed by fire in the 1880s at a heavy loss.

A conservative estimate in 1915 of the apple crop around Hamburg was set at 170,000 bushels for commercial orchards. Among the foremost growers were A.A. Simons (above), G.C. Farley, J.M. Bechtel, A.L. Hurley, C.E. Mincer, George Stafford, E.V. Wright, Cliff Good, and Mrs. D.S. Woods. A severe freeze on November 11, 1940, (Armistice Day) killed or severely injured many apple trees.

This plant was first known as the Hamburg Canning Company and was the largest corn-canning plant in the state of Iowa. Later, it was purchased by Otoe Food Products Company. Spinach, pumpkin, asparagus, peas, and cherries were added to the packs. More than nine million cans of date roll and a similar number of cans of chicken were processed as part of World War II contracts.

The Farm Bureau Auxiliary of Washington Township had an exhibit at the county fair held in August 1925 that attracted considerable attention. The central figure was a miniature oil derrick from which flowed a constant stream of oil. The oil well of Hamburg fame is located in Washington Township, where drillers struck oil (though not paying quantities) in July 1925.

Alex Vogel entered the popcorn business in 1941 under the name of Vogel & Son Popcorn Co., being associated with his son, Arthur, in the business of contracting with farmers for growing popcorn. Vogel Popcorn is responsible for approximately 50 percent of the total annual popcorn production in the United States. Golden Valley Microwave Foods, manufacturer of the ACT II brand of popcorn, acquired Vogel Popcorn in 1987. ACT II is presently made and distributed by ConAgra Foods.

Souvenir Rose Guide

to a living display of the world's finest roses
6475 PLANTS ———— 104 VARIETIES

HORTICULTURAL DIVISION
CHICAGO'S
CENTURY of PROGRESS
EXPOSITION
1933

Planted and Exhibited by
INTER-STATE NURSERIES
HAMBURG, IOWA

By the early 1930s, Leslie, Carl, and David Sjulin had built a successful "direct-to-you" mail-order nursery. At the 1933–1934 Chicago World's Fair, they set up a magnificent rose garden that bloomed on cue when the fair crowds arrived. The garden was located near the place where the famous Sally Rand did her exotic dancing. It is said that while men watched Sally, thousands of women whiled away the hours at the Inter-State Nurseries rose garden.

The 1937 Peony Festival coronations of the king and queen were elaborate ceremonies as seen here. Many Hamburg citizens, together with Inter-State Nurseries, made the event possible. Thousands of peony blossoms were provided for decorating floats, businesses, and houses.

Here is a view of the large crowd attending the Liberty Day celebration, which occurred on April 26, 1918. The middle flag, with its field of stars, has one for each man in the military from the Hamburg area. The bottom flag is the liberty loan flag with the two stars representing the doubling of the quota for the third liberty loan drive.

Howard Colon selected *The Valley of Giants* to be the first film shown at the theater opening in 1920. The entire interior of the building was rebuilt and redecorated in 1930 for sound pictures. The theater had been closed for 15 years before renovation began in 1988 at a cost of about $90,000. Today, the Colonial shows movies on Friday, Saturday, and Sunday evenings.

Early firefighters had to depend upon a bucket and pump and the borrowed ladder of a neighbor. But after the waterworks was completed, the volunteer Hamburg Hose Team blossomed with a hose cart, hook and ladder, fancy uniforms, and helmets. Along came the motorized age, and a Ford fire wagon was purchased in 1917.

O.G. Lorimor opened his photography studio in 1906. Many of the photographs in this chapter were scanned from glass plate negatives taken before there was sheet and roll film. For 50 years, every graduate from Hamburg High School, with a few exceptions, had his or her picture taken in the Lorimor studio.

Four

SIDNEY
CROSSROADS OF THE COUNTY

In 1851, the decision was made to move the county seat from Austin, located near Hamburg. A government commission was to choose a location in the center of the county and designate it as the county seat. Then land near that spot that was for sale had to be found. The search resulted in Milton and Jane Richards selling property to the commission. Mrs. Richards was asked to name the municipality, which she did after her hometown of Sidney, Ohio. The town soon became an important supply center for immigrant wagons headed west. At one time, a dozen or 15 covered immigrant wagons, with 75 to 100 oxen attached to them, stopped by the town. By 1856, stage lines ran through Sidney, and in 1859 gold-seekers came through. Sidney was truly a crossroads. Fine hotels with distinguished guests were part of the city scene. The *Fremont Herald* newspaper had just started in 1858 when it reported a population for Sidney of 500. By 1870, it had grown to 1,000. The townspeople established schools, churches, businesses, and organizations. One such organization, the Old Soldiers Reunion, formed in October 1889 and grew into the present-day Sidney Iowa Championship Rodeo. The rodeo remains a yearly celebration for the town.

Through the 1900s, the town square was lined with businesses, with the courthouse dominating the middle. Saturday night was a time to listen to the band and shop the many stores.

Following the survey of lots, the first sale was June 29, 1851. It was purchased by Stephen Cromwell, who built the first hotel in Sidney, the Cromwell House. The first marriage in Sidney was held there. Patrons of the Cromwell House included fortune hunters in route to the goldfields and Chautauqua performers. Jenny Lind, the "Swedish Nightingale," spent the night and entertained the Cromwells and their guests. Ulysses S. Grant signed the guest register. This register included a page of advertising. Only one business that advertised in the book still exists: Penn Drug. The Cromwell House was moved to a site east of the Methodist church and is now a private residence.

By 1877, the demand for railcars for crops required added rail lines. The line from Hastings, Iowa, into Sidney was built by the Nebraska City, Sidney and Northeastern Railway. It was completed on December 2, 1878. The depot pictured was the only one ever built in Sidney. William Dyke served as the station agent many years with Al Akins taking over as Sidney agent from 1950 until the facility's closing in 1966. The depot's telegraph wire call was SD in Morse code, which was phased out and replaced by railroad closed-circuit telephones.

Sidney was located 21 miles from Hastings. Since this was the end of the rail line, Sidney required a turntable upon which the engine was turned around so it was headed in the right direction for the trip back to Hastings.

This Sidney street scene dates to 1908, showing the west side of the square. The mode of travel is horse and buggy with hitching posts placed along the full length of the courthouse yard. The telephone poles are set in the sidewalk with many lines high over the street. In 1976, the *Sidney Argus-Herald* ran the picture with the caption, "this no one-horse town."

The street scene dates to 1938 and shows the same general area as the previous photograph. Motor vehicles have replaced the horses and buggies, with parking on both sides of the street.

In 1963, the *Sidney Argus-Herald* honored Penn Drug by publishing a special supplement on the pharmacy's 100th anniversary. In 1980, on the 100th anniversary of the *Iowa Pharmacist*, it was announced that Penn Drug Co. was the oldest operating pharmacy in Iowa. Today, Penn Drug Co. is still in operation and still owned by the same family. It began in the 1850s when John Newton Penn and family journeyed from Athens County, Ohio, to Sidney to set up a medical practice. He built a drugstore in Sidney in 1864, when he combined his practice and the preparations of medications. Penn treated the only Civil War casualty in the county. A local boy was shot when a group tried to stop Confederates from Missouri who came to Fremont County to steal much-needed horses. In 1880, John's son Alphonso "Phon" Penn Sr. became one of Iowa's first registered pharmacists. Alphonso "Val" Penn Jr. joined the firm in 1910. In 1949, Val's son William A. Penn continued the business with his son Jeff, the current manager.

The Old Soldiers Reunion began in 1889 to renew friendships of men who served together in the Civil War. It was fading away in 1923 when the American Legion, in an attempt to save the reunion, started a rodeo. The two Tackett brothers and Art Fritcher, who had recently returned from Wyoming, provided entertainment by riding wild horses for the sum of $50 for four days. This event's success started Iowa's Championship Rodeo in Sidney

The social event of the summer was the Chautauqua. The event, held in several communities, usually lasted for a week in August. This picture of Sidney in the early 1900s shows all of the tents that were pitched for the event. In Sidney, the Chautauqua was part of the Old Soldiers Reunion that eventually became the rodeo.

A growing population required the constant upgrading of schools. In 1851 a blue-painted brick building was used but soon overflowed. Next came this third building to serve as a school. It was used to bivouac Civil War soldiers. When it became obsolete, a local businesswoman, Nell Carl, purchased the structure for her personal residence.

High School, Sidney, Iowa. J. F. LEWIS, SOUVENIR POST CARDS

Originally, this school, built in 1872, had four rooms but was expanded to 13 rooms by 1880. From 1882 to 1884, Charles Henry Dye and his wife, Eva, were the high school faculty. Later, Eva became a famous author and historian. The first graduating class was in 1885. All 12 grades were in the building until 1916. Today, Sidney is one of the four remaining school districts in the county.

Fremont County's first courthouse was built of logs in 1852. In 1859, the building was sold and a new brick courthouse was constructed. During its 30 years of existence, it was damaged with explosives and fire that were rumored to be an attack because of supposed Southern sympathizers, but that was never proven. The building burned in May of 1888. The new courthouse, built in 1889, had a high tower that was struck by lightning in 1910, resulting in the tower being removed. The structure still serves the county today. During World War II, guards walked the roof of the courthouse watching for enemy planes. There is no record that they saw any.

This quaint bungalow located on Filmore Street just west of Sidney's town square was home to George and Nellie Chappel. It was not famous because George was a doctor of osteopathy but because Nellie was a practicing palmist. Her talent was visibly displayed by the large palm-shaped sign in the yard. Always smartly adorned, this petite lady commanded quite a following throughout the 1930s and the early 1940s.

"Progress" has closed many businesses throughout Sidney, especially full-service gas stations. L.V. "Shorty" Birkby, proprietor of Skelly Oil Station, sold out his interest in Skelly and moved his business north of Sidney. Time and the economy forced the business to close. Other stations, such as Barnard Service, Ballinger Sinclair, Dugger Oil, and Bobbitt's Service all succumbed to the demands of change. Note Shorty's white shoes and uniform.

Bands have been part of Sidney since its beginning. An article dated July 4, 1858, tells about the Sidney Brass Band celebrating the 82nd anniversary of Independence Day. Forty-one years later, a picture of the band appeared in the local paper. The group played on the courthouse lawn on Saturday evenings in the summer. In the 1900s, band members received a coupon for ice cream at the Hollywood Ice Cream Store as their "pay" or "treat."

A favorite hangout for ladies and kids was Rubink's Store. The business took over Nell Carl Dry Goods Store in 1948. It became a variety store with a beauty shop in the back. The biggest attraction was the candy counter. When kids came in with a single penny, Nona Rubink patiently allowed each of them plenty of time to make a selection.

The Knights of Pythias, a men's fraternal organization, met in the 1800s at the KP Hall located on the southeast corner of the square. In the early 1900s, the building housed the Independent Telephone Company. The Knights of Pythias continued to hold their monthly meetings on the top floor of the building through the 1950s.

In 1926, the Middle States Utilities Company opened a telephone office in Sidney as well as offices in neighboring towns. The employees had monthly theme parties. This picture is of a "kid party." Note the hair ribbons and various children's paraphernalia. The rural phone lines were party lines with no less than 10 subscribers who were identified by short and long rings. With the aid of a night operator, service was available 24 hours a day.

The Crozier Hotel, later the Hotel Sidney, was known for fine dining. The dining room was in the back with sunny west windows and a wooden floor. Through the 1930s, it was the place to go for gourmet food and ambiance. The dining experience included live entertainment. A Sidney street scene from 1915 shows the Crozier Hotel (at the right) along with other business on the west side of the square

Dr. Kenneth Murchison received his degree from Iowa College of Medicine in 1903 and practiced in Sidney from 1921 to 1957. He represents all of the doctors who served Sidney, beginning with Joseph Venable in 1843. In 1927, the *Sidney Cardinal* yearbook article "Sidney Schools First in State" states that the free work of doctors Lovelady, Nelson, and Murchison allowed Sidney schools to be at the head of the state in immunization against diphtheria.

John "Scott" Redd was born September 10, 1944, and was raised and educated in Sidney. Following graduation, he received an appointment to the United States Naval Academy. Redd enjoyed a brilliant career in the Navy, rising to the rank of vice admiral, with his last command being director of the National Counterterrorism Center. In October 2007, part of the State Highway 2 bypass around Sidney was named the Admiral "Scott" Redd Highway.

Ralph Lovelady, a 1907 Sidney graduate, joined his father, Dr. James Lovelady, in Sidney after serving as a World War I medical officer. He practiced until his death in 1968. A feature in the March 20, 1987, issue of the *Sidney Argus-Herald* tells of a typical office call for a girl: "He would stick his head out the office door saying, 'Come on back, girlie.' You sat on a chair opposite him. He'd slap his knee and tell you a joke. Then he'd roar with laughter. Soon he was all business asking, 'Now, girlie, what's the matter?' He'd check nose, throat, and ears, eyes, and listen to see if you were breathing. Soon you would leave with a plump white envelope of pretty pills. You felt better and usually got well. If you didn't, he came to see you. If he couldn't help you, he wasted no time getting you where someone could."

Five

TABOR
Town with a Story

The first settlers of Tabor came from Oberlin, Ohio, with the dream of starting a Christian college like the one in Oberlin. They first settled along the Missouri River and named their settlement Civil Bend. Floods, mosquitoes, and fever soon drove them to higher ground. In 1852, some of them moved to the hill that is now Tabor.

Tabor's settlers had covenanted to do everything they could to live long and healthy lives they would devote to God and God's people. They avoided alcohol, tobacco, tea, and coffee. They ate simple wholesome foods, wore simple clothing, and lived in simple homes. They pledged to work hard and make all they could above what they needed for living so they could give more to God's work. George Gaston pledged half his assets to the building of the college. The Reverend John Todd pledged more than a year's salary, and teachers taught without pay for one year.

Although the settlers were pious and law-abiding people, they felt compelled to break the law when it came to assisting slaves to pursue their freedom. They gave freely of whatever they had of their strength and time. The men spent many uncomfortable and even dangerous days and nights escorting freedom-seekers on their way toward safety in Canada. The women welcomed escaping slaves into their homes and faced down slave catchers.

Tabor residents also opened their homes to settlers moving from the East Coast to Kansas in order to help bring Kansas into the union as a Free State. Soldiers sent to escort the settlers into Kansas camped in the park.

The dreams of a Christian college came to fruition, and Tabor College provided excellent educational opportunities for approximately 60 years. The college closed in 1927 after years of financial troubles. Student records were sent to Doane College in Crete, Nebraska, and Tabor's excellent college library was sold to Omaha Municipal University. During World War II, two of the college buildings were used to house German prisoners of war.

For approximately a century, the population of Tabor has hovered around 1,000 residents.

Tabor's first house, built in 1852, belonged to George B. Gaston. The Gastons, who were heavily involved in the movement of slaves to freedom, frequently found their home filled with fleeing people staying there until it was safe to travel. Their house was located at the southwest corner of the park and was torn down in 1979.

The Todd house, home of the Reverend John Todd and a station on the Underground Railway, was built in 1853 of native wood. The timbers were oak, and the siding was cottonwood. Deacon Samuel H. Adams made the doors and sashes of black walnut. The foundation was adobe. During the Kansas free-state fight, 200 Sharps rifles were kept in the basement, and a cannon was stored in the barn. Later, the rifles were taken to Harpers Ferry. The cannon was sometimes used in local celebrations.

The stately, three-story Gaston Hall was built with funds from 15 states, one territory, and Mexico. It was dedicated on April 21, 1887. The "cow on the third floor one Halloween" is a story still told today. The clock tower was still in working order when the building was torn down in 1951.

Woods Hall, built in 1869, was originally known as "Boarding Hall" and "Ladies' Hall." It was a three-story structure that housed Tabor College female students on the second floor and male students on the third floor. The first floor had a kitchen, dining room, and reception parlors. As the college grew, the first floor dining room became the library, and the large parlor became the museum. On September 1, 1980, the demolition of Woods Hall began, much to the chagrin of many Tabor residents.

The College Conservatory, Adams Hall, was built in 1902, at the west end of the campus and replaced the older frame building known as "Music Hall." The president's office, the YMCA and YWCA rooms, the Phi Kappa Hall, and a grand auditorium and practice rooms were located in Adams Hall.

A heating plant with two large boilers was built on campus around the time Adams Hall was erected. Here, men dig lateral lines to furnish steam heat to Adams Hall, Gaston Hall, and the college gymnasium. Water for the heating plant came from a well on campus. Water was also pumped to an elevated water tank in the upper part of Gaston Hall. The water was plentiful enough to supply the college buildings and, in time of emergency, the town.

In 1848, the Reverend John Todd came with a group from Oberlin, Ohio, to establish a Christian college in southwestern Iowa. He not only pastored the Congregational Church of Tabor for 30 years, but, according to the *Early Settlement and Growth of Western Iowa*, he "covered a monthly circuit area 100 by 40 miles and services were held at 8 to 10 places." He helped to start other churches, among them the Congregational churches in Glenwood and Sioux City. Todd took an active part in civic and college affairs. For many years he cultivated "several acres of ground, kept cattle and horses, kept a timber lot from which he got his own fuel." Todd was "endowed with an excellent physique, a thorough education, a beautiful voice, a devoted spirit . . ." He retired from the pastorate at age 64 but remained active. At the time of his death, he was circulating a pro-temperance petition.

With a growing student body, the need for a church building to benefit the college was evident. The Congregational church was finished in 1875 in time for commencement. It was made of brick from a local brickyard. Limestone for the foundation was hauled from the Thurman quarry on Bluff Road. The cost was $22,000 plus donated labor. It had a seating capacity of 1,000, a large pipe organ, and wonderful acoustics. Many college oratories and concerts were held there. The building withstood two major catastrophes: a tornado in 1907 that destroyed the north end of the building and a fire in 1947 that destroyed the interior. It was remodeled to seat 300. The exterior remains unchanged.

The Tabor & Northern Railroad, also called the "T&N," was unique. First, it was the shortest standard gauge railroad in the world, and second, it was known for jumping the tracks. Established in 1890, the T&N was owned by Tabor College. The railroad's first president was Prof. Dean McClelland. The tracks ran diagonally between Tabor and Malvern for 8.79 miles and served the communities for 39 years. The end of the railroad began when the state highway commission revealed plans for State Highway 275 to be constructed as a major north-south route through Tabor.

The shady, 10-acre Tabor City Park, where abolitionist John Brown drilled his men in the 1860s, was the site of many picnics, reunions, and baseball games. This picture was taken at a Tabor baseball tournament in 1911. The men in suits and hats and the ladies in dresses and hats were wearing accepted styles. Other park memories were the Farmers-Merchants Picnics held each summer with parades, reunions, outdoor worship service, plenty of entertainment, and good food. Tabor City Park is on the National Register of Historic Places.

The lovely, old brick building with a white cupola on Center Street was the Tabor Grade School. Students thought it was fun to slide down big tubes during fire drills, though this picture was taken before the fire escape "tubes" were added. In February 1949, fire destroyed the building during the night.

The old Tabor High School, located at the corner of Orange and East Streets, was built in 1918. Students remember class pictures hanging in the hallway and looked forward to seeing their class's photograph. The second story housed the auditorium with tall windows on the south side. A pole with a hook on the end was used to raise and lower the upper windows for ventilation. The building was sold in 1971. The cornerstone of it was given to the Tabor Historical Society.

Quiet Main Street in Tabor turned into a bustling town on Saturday evenings. That is when people came to town to do their trading. Men used the time to go to one of three barbershops for haircuts, while the ladies did their visiting, catching up on the happenings of the past week. There were two drugstores, three grocery stores, seven gas stations, a women's clothing store, a men's clothing store, a hardware store, and a variety store to fulfill every need for the upcoming week. There were also several eating establishments. The band played on Saturday nights in the summer for the enjoyment of both young and old. At one time, before Main Street became part of Highway 275, the street was paved in brick. Notice the traffic light hanging in the intersection.

In 1893, a devout group of people purchased 40 acres in the southwest part of Tabor and established the Hephzibah Faith Missionary Association. People from other states sold their property and moved to Tabor in order to put their children in the Faith Home School. There were sometimes as many as 100 orphans in the Faith Home orphanage. The association sent out more than 100 missionaries to China, Japan, Africa, and Haiti.

In the summer, the Faith Home School had weeklong camp meetings. In 1939, the tabernacle replaced the large camp meeting tent. In the 1940s, several community leaders died, and fire destroyed the school. The church property was given to the Church of the Nazarene with the provision that they continue the camp meetings. The meetings still draw a crowd from a large area.

Students at the Faith Home School dressed in a way that set them apart from other children in town. One former student said she had to shut her eyes tight while her mother braided her hair if she hoped to close them later in the day. The children were not allowed to read *The Adventures of Tom Sawyer* or fairy tales. But they adored their teacher, Emma Herr.

The Faith Home School dormitory was built from 1929 to 1931. It was the best and most expensive building on the grounds. When it was no longer needed as a dormitory, it was used as a rest home. It has since been torn down.

73

This drawing, probably made in the 1870s, represents a view of Tabor from the park, showing the buildings of the college: the chapel, church, residence hall, and music hall. The properties were fenced to keep out wandering livestock.

Six

Percival, Thurman
Courageous Pioneers

The settlement of two of the western towns in northern Fremont County revolved around the Missouri River and then the railroad.

Percival's history is linked to the settlement of Benton Township, first called Fulton Township, located on the Missouri River along a large bend in the river. Settlement began on the river shore and gradually moved east. Many of the early historical events of the county took place in the area known as Civil Bend, located on the river bend. The area was an important river port for early traders. The first settlers arrived in 1843, coming from Kentucky and Ohio. As they built their homes, they experienced many problems with Native Americans. On January 18, 1849, the first post office was opened and named Gaston. Then, as settlers moved east, the village of Eureka was established in 1857. It was a stagecoach stop with a hotel for travelers. A school and church were established. One business was a sawmill owned and operated by Henry Brockies. A short distance east of Eureka, the Kansas City, St. Joseph & Council Bluffs Railroad came through, and settlement began to move towards the railroad tracks. In September 1868, in a new location, the name of the village became Percival.

In July 1846, a battalion of 550 young Mormon men, along with helpers herding livestock, marched down Bluff Road from Council Bluffs, headed for the Mexican-American War. Their cattle wandered into the hills in the area that became Thurman. When the women found the animals, they were in a grassy area with a creek and plum trees in bloom. Five of the women decided to stay and let the battalion go to war. The resulting town was first called Plum Hollow because of the wild plum trees along Plum Creek. Later, the railroad in McPaul influenced the development of Thurman, resulting in a prosperous community known for beautiful homes.

Christopher "Kit" Keyser and Olivia Lambert were the first white couple married at Civil Bend, on October 9, 1851. There were nearly 400 wedding guests, as all the white folks in the area were invited. Christopher and Olivia were married by the Reverend John Todd. The wedding cost $400—an enormous sum at the time. They were descendents of the first settlers and were truly pioneers; at the time, when the county was mostly occupied by Otoe and Pawnee Native Americans. For nearly 20 years, the Keysers' supplies came up the Missouri River by boat or were freighted overland from St. Joseph, Missouri.

Percival was named in honor of Robert Percival, a prominent lawyer and educator, who donated land for the town.

Pictured is Main Street in Percival, looking south, with Hawley's Store, established 1867, in the foreground. Elizah R. Hawley, known as "Uncle Lige," came to the area in 1864 and took a tract of land. For years he had the only fenced farm. When the railroad came to town, he became a storekeeper. The Percival Post Office was located in Hawley's Store, and W.H. Sheldon was the postmaster.

Parkison's Store was opened in 1894 by Amherst and Louise Parkison. Stock included green coffee that could be roasted at home. Refrigeration was ice cut from the river and packed in sawdust to last through the summer. A Council Bluffs salesman came with an amazing new product: commercially baked bread. Twice a week a wicker basket arrived with unwrapped bread and soon the store was selling 25 loaves a week.

Percival grew along the railroad tracks. The main street, shown here in 1908, though it was on the east side of town, was named West Street due to being on the west side of the railroad. By 1876, there was a tavern, dry goods stores, drugstore, shoe shop, blacksmith, wagon shop, beer saloon, and doctor. In the foreground is Parkison's Store, and in the back is E.W. Sheldon's grain elevator.

The depot was built on the Kansas City, St. Joseph & Council Bluffs Railroad. Supplies and mail were brought by rail. Saturday-night movies shown on the side of the depot were sponsored by the merchants for farm families bringing their cream and eggs to town to be sold. Proceeds were used to buy their weekly supplies.

The Percival School started in 1864 as an elementary school. Years later, several country schools merged with Percival, and these school buildings were used to enlarge the existing structure. A separate building that became a lab and manual training facility, and was later used for fifth and sixth grades, was called the "doghouse." The first graduating class with a 10-year diploma was in 1915.

Six one-room country schools dotted the landscape of Benton Township in 1891. Most schools were located near a family farm. Ricketts, Sheldon-Keyser, and Treat Schools were named for local families. Eureka, Prairie, and Eastport were the other schools. Pictured are teacher Adelia Wadhams and 30 students inside the Eureka school in 1908. The first girl in plaid in the front row returned to that school in 1921 as the teacher.

1920 ♦ 1960

CONGREGATIONAL

METHODIST EPISCOPAL

BAPTIST

PRESENT DAY CHURCH

Forty Years of Christian Unity

"For Christ and the Church"

On September 15, 1920, for the first time in America, three churches—the Baptist, Congregational, and Methodist—were federated into one. In 1927, Percival needed a community center. The new building was constructed using salvaged materials from the Methodist and Congregational churches. Later, a parsonage was built with the lumber from the Baptist church. In 1960, forty years of Christian unity from this federation was celebrated.

The church that was erected for the federation is still in use today. Many weddings, funerals, and community celebrations have been held here.

Grain shipping in the 1930s and 1940s was huge in Percival. Two elevators stood at the north and south ends of Main Street. In the earliest days, horse-drawn wagons brought the grain to be sold. Later, small grain trucks were used, then semis that could hold 1,000 bushels. The vehicle crossed a scale, unloaded, and then weighed again to determine the amount of grain sold for the price offered that day.

Hineline's was the only café in Percival during the 1930s and 1940s. Hamburgers, soups, and Hattie's homemade pies were served during lunch when students walked from school for a quick meal. The school did not provide a hot-lunch program until the late 1940s when a building was built using salvaged materials from the old schoolhouse. Occasionally, John Freeman called ahead for a meal for his corn-shelling crew.

Plum Creek provided a route to Tabor from Thurman. Mills, icehouses, and schools dotted the way along the creek. Waterpower was used for the mills. This route was well traveled. While never proven, there are some who think it may have been used as part of the Underground Railroad. This particular mill was one of the first ones built in the early 1800s.

In 1851, Abraham Fletcher taught students in his home. The first school building erected in 1852 was located at the foot of Grasshopper Hill.

Two years after the Mormon battalion marched through, the town of Thurman started in 1848 when Abraham Fletcher built his house. Fletcher laid out the city in 1865. In this photograph, a stagecoach arrives along the dirt main street. Plum Hollow changed to Fremont City, then changed again because Nebraska already had a Fremont City. The final name was chosen to honor Allen G. Thurman, who was vice presidential candidate on Grover Cleveland's 1888 ticket. In the late 1800s, the town of 500 was a thriving business area. Services included dry goods stores, a drugstore, millineries, a tavern, blacksmith shops, wagon shops, a restaurant, shoe store, meat market, saloon, and harness shop. A large flour mill operated with three pairs of stones. Three doctors served the community. The lumberyard sold about $15,000 worth of goods yearly. The Methodist church was built in 1857, and the United Brethren Church was erected in 1874. All prospered because of the Kansas City, St. Joseph & Council Bluffs Railroad in McPaul, three miles to the west, where thousands of dollars of grains and livestock were shipped out each year.

The McCartney Hotel replaced an earlier one that burned. In the early 1900s, passengers arrived daily in McPaul. They were brought to Thurman on horse-drawn drays. When the train was delayed, passengers stayed the evening. Good meals were a highlight of a stay at the hotel.

The United Methodist church was organized in 1855 and is said to be the oldest in Scott Township. The earliest church services were held in a log cabin at the base of Grasshopper Hill, just to the south of Thurman. The current building was built in 1885. The 379-pound bell was purchased for 36¢ a pound. The pulpit was made of native wood and is still part of the church.

The McCartney Building, built in 1900 for multiple uses, was the largest building in Thurman. The owner, Herman McCartney, had benefited from an excellent business course at Iowa College in Iowa City. There were stores on the first floor and a dance hall upstairs. The upstairs was also used for other forms of community needs including a finishing school to benefit young ladies. Downstairs, the L.S. Ambler Store operated a fabric business. Because of the prosperous residents, the store could stock a wide variety of fabric and sewing supplies.

Sherman Surface was an astute business man who knew how to change with the times. This picture of his meat market in 1929 shows him, his son Lowell Dean, and daughter Betty Jean, with wife Hazel looking through the window. When grocery stores came to town, a meat market could not survive. Surface bought a grocery store and put his meat market in it. During the 1940s, the Surface Market was the place to be on a Saturday night for good conversation.

C.R. Paul purchased the first automobile in Thurman. It was a 1901 Oldsmobile. The story is that Paul had his auto delivered by train to McPaul. When he picked it up, he did not know how to change gears, so he drove in reverse for the three miles back to Thurman.

The *Council Bluffs Daily Nonpareil* reported on March 3, 1913, that Thurman had the largest number of stately homes of any town its size in Iowa. Additionally, it reported they were more elegant with more modern equipment than those in other towns. This prosperity was attributed to the railroad in McPaul and the dozen citizens that amassed personal wealth of a million dollars between them. Today, these stately homes are still landmarks.

Downtown Thurman in the 1940s was changing; there were gas stations and a movie house. Business was good. On Saturday nights, families came to town and left their orders with the grocery store for the clerks to fill. Families passed the evening away at the movies or joining in conversation. Stores started to stay open until 1:00 a.m. so orders could be picked up.

In 1878, a brick, two-story schoolhouse was built at the southeast corner of Thurman Park. The schoolhouse was named the Independent District of Fremont City, and the first year there were 213 students registered with two teachers. The first graduating class was in 1887 with eight students. In 1893, the school was named Thurman School. This building was used until 1921 when it was replaced with a new structure. The final year of high school in Thurman was 1959.

Seven

RANDOLPH, IMOGENE
PRAIRIES AND CHURCHES

In the 1850s, several families heading west settled along the banks of Deer Creek in Riverside Township. The settlement lasted until 1878–1879, when people moved west to the railroad lines and Deer Creek became one with Randolph. When the railroad laid tracks through the area in 1878, Anson Rood and Volney A. Bass donated farmland for a town. Homes and businesses sprang up quickly. A post office was established in 1879. Samuel Becker opened the first mercantile, and Mary Johnson built the first house from cottonwood. Spencer Brothers, Addy Brothers, Stout's Grand Hotel, Rhodes Elevator, a bank, two churches, and a train depot were among the 46 businesses that were here in the early 1890s. By 1918, the town supported three general stores, two banks, furniture, lumber, drug, and hardware stores, a newspaper, hotel, opera house, dentists, two doctors, a barber, icehouse, livery stable, restaurants, implement dealers, a blacksmith, apple packing plant, produce house, two churches, and a meat market.

The western exodus of Irish and Germans from the Zwingle/Dubuque area of Iowa to "Little Ireland" in Monroe Township began in the 1870s. More settlers came with the railroad. Captain Anderson obtained townsite papers on November 6, 1879, for 160 acres owned by Edgar Faust and named the town after his daughter Imogene. H.W. Crosswaite bought the first lot, and J.A. Rose built the first house in the town. Imogene was incorporated on February 18, 1881, with L.K. Hutton as mayor. By 1890, the population stood at 400. When 1900 dawned, several blocks of businesses made Imogene a vibrant community. Town fires, the desire to continue pioneering west, the lack of a town water supply and sewer system, economic downturns, and smaller families all caused Imogene to decline to a population of 56 in 2010. Many town and country residents and area alumni have banded together as the Sons and Daughters of Imogene in hopes of revitalizing the town.

Taken in March 1909, Main Street in Randolph is believed to be preparing for a farm auction. The buildings on the west side of Main Street are, from the far left, the blacksmith shop, then the hotel, the meat market, icehouse, and hardware store. Teams of horses, buggies, men in suits, and women in long dresses wait for the auction to start.

In 1881, the town's first bank, the Bank of Randolph, was built on the southeast corner of Main and E Streets. The bank president was Anson Rood, thought to be the man on the right. Next to the bank is possibly a furniture store. Note the chair on top of the building and the table and rocker in front of the store. Wooden sidewalks indicate the picture was taken shortly after the bank was built.

The Armstrong Cash Store, built in 1915, was on the corner of Main Street and the "East and West" Road, now Highway 184. The store advertised ribbons, ladies undergarments, stockings, fabric, a pair of curtains for 50¢, and a bedspread for $1.83. Typical of stores of the era, the shelves were stocked with a great variety of goods. The building later housed the Red and White Grocery operated by "Shorty" Russell. The last owners were Thain and Betty Marshall.

D.W. Thomas (most likely the man with the broom) ran Randolph's west side drugstore in the early 1920s. Notice the sidewalks are cement. The Masonic building was on the far right. A café appears to be on the left of the drugstore because one can see "lunches" printed on the window. Lots of awnings were hung on buildings to help keep them cool. Thomas served soft drinks and ice cream.

Wilson Hardware always had just what the customer needed. For over forty years, "Tag" repaired lawn mowers and small appliance, found the needle that would fit a sewing machine, delivered bottles of propane for cookstoves, and played jokes on his friends—all the while playing cards with whoever showed up that day. The upstairs of the building was used by the Odd Fellows and Rebekahs.

The original Randolph School burned in 1915. Classes were held elsewhere until a new structure was built. Upon consolidation in the 1960s, the school building was eventually torn down, and the Randolph City Park was created. School spirit was always strong, beginning with the basketball and football teams. Pictured in front of the school is the girls' basketball team of 1926–1927. Many trophies were won by the school's teams and they are on display at the Randolph library.

Established in 1879, the first postmaster of the Randolph Post Office was S.C. McKetrick. Postmaster Alva Gillette's (1908–1930) family lived above the post office. One customer recalls knowing what was for dinner from the aromas wafting throughout the post office. This 1940 photograph shows snow did not stop rural carrier Harry Comstock (on the right) from delivering the mail. Note the sacks piled on the truck.

Fall festivals for Randolph brought together farm and town folks for a day of festivities, including children's games and a parade. A free supper was provided as well as free outdoor movies, bingo, tractor pulls, frog-jumping contests, garage sales, dances, and bake sales. Crowds gathered for a meal on Main Street.

In 1874, the Presbyterian church organized. In 1880, it constructed a building. Previous to that, church services were held in the depot. An organ owned by the church provided music at the depot. Known as the "little white church," the original structure burned to the ground. A new church was erected in May 1926. In 1959, this church housed the first Randolph library, with Cora McCord serving as librarian.

The First United Methodist Church was built in 1885 and was made of wood. In 1916, a new, larger, brick church was erected. Wood from the first church was used to build a parsonage, which still stands on Lambert Street but is now a private residence. The church is proud of its beautiful stained glass windows and its record of services every Sunday for more than 125 years.

The last train through Randolph was in 1962. The depot sat empty until 1979 when it was purchased by Roy and Gladys Davis who moved it to their farm and restored it. The Dave McGargill family gave it back to the town in 2008. It is now the Randolph Museum, which provides information about the railroad days. It houses a baggage room and ticket office where patrons can find a ticket agent helping a World War I soldier.

Built in 1871 by Anson Rood for his family of eight children, this 12-room Italianate home has endured two world wars, the Great Depression, and the tragic deaths of children. It houses the belongings of three generations of the Ferrel family. Now owned by the Fremont County Historical Society, the Ferrel house aptly tells the story of early living in Fremont County, from the late 1800s to the 1940s.

August Werner and his wife, Mattie, were among the earliest residents of Imogene. Originally they ran a restaurant and boardinghouse, then they built a house and carpentry shop. August had success in building model helicopters. On July 4, 1886, he flew a full-sized helicopter a few feet off the ground before it crashed. After December 1886, this aviation visionary spent the rest of his life as a carpenter in the Clarinda Mental Institute.

Until the 1930s, the Imogene Road went north on 395th Avenue, east across a bridge, made a turn north on Railroad Street to Second Street, east past Main, Market, and Walnut Streets to Cherry Street and south to just west of Mount Calvary Cemetery. Businesses lined several streets. The Charles Gee Grocery and Post Office, Charles Deppe Store, and H.J. Smith Meats shop were on the west side of Main Street, north on Second Street.

St. Patrick Catholic Church was established on June 21, 1880. A white frame church was completed in 1882, and ten years later a brick church to seat 280 was built. A noted orator, world traveler, and independently wealthy person, Fr. Edmund Hayes served at Imogene from 1888 to 1928. Always a promoter, Hayes was influential in bringing Irish settlers to Imogene and electricity to the town in 1916.

By 1899, there were Catholic, Methodist, Free Methodist, German Lutheran, and German Reformed churches in Imogene. The Methodist church was located on the northwest corner of Third and Walnut Streets. When the church was torn down, the lumber was used to build the current Bud Laughlin home across from Mount Calvary Cemetery. Across the street to the southwest was the Free Methodist church that later became Hibernian Hall.

A Presbyterian church across from the Catholic church became the German Lutheran church and later the St. Patrick Parochial School. This church and school was torn down in 1919. It was replaced by a brick convent in 1922 and became home to Dominican sisters until the 1970s. Today, the building is the Faith Center, used for religious education classes.

Thomas Hann built the Free Methodist church using Chicago knot-less white pine lumber. Early in 1901, the entire congregation moved to Kansas. The Imogene Ancient Order of Hibernians organized and bought the church to use as their AOH Hall. It became the center of Imogene social life. Lawrence Welk and the Monte Carlo Band played there in 1927.

Wood from the original St. Patrick Church was used in the construction of the rectory which was first occupied on October 19, 1904. The roof caught fire when the second church burned in 1915. While the bucket brigade fought the fire on the roof, furniture and priceless books and artifacts were thrown out the windows and destroyed by water and mud. Even the green marble fireplace surrounds were pulled out.

On September 9, 1907, St. Patrick Academy, located behind the church, opened with an enrollment of 100. Teachers were Mercy Sisters (1907–1918) and Dominican Sisters (1920–1969). The sisters lived in the rectory, and the pastor lived on the top floor of the school until a convent was built. About 1,000 students received an education at the academy before it closed in May 1969.

By 1914, the east side of Railroad Street was teeming with business. In 1955, this same block contained the Cahill Bank, Addy Grocery, Clyde Addy Television, an amusement machine shop, Miller Tractor Warehouse, First National Bank, Kamman's Store, Hayes Tavern, a garage, storage building, and Skahill Grocery. Today, two empty brick bank buildings remain. The Emerald Isle was built on the south end of this block.

The current 130-foot-by-65-foot St. Patrick Church with an 80-foot bell tower was built between August 1915 and March 1919 for $125,000. It replaced the 1892 church that burned in February 1915. The north wall went up twice because Fr. Edmund Hayes said the original brick was an inferior grade, so it was removed to the foundation. In 2010, there were 150 families in the parish.

The white Carrara marble altars in the 1915 church came from Pietrasanta, Italy, and were a gift to the parish from Father Hayes in memory of his family. Hayes's first pick of altars sank when the ship carrying them hit a German mine. He sent the St. Patrick glass window in the choir loft back three times because the face was not right. Is it Father Hayes's face in the window?

Various buildings served as Imogene Public School. A Mr. Grubb was the first schoolmaster. The last schoolhouse was built right across the street to the north of the St. Patrick Academy. Sometimes, academy teachers evacuated their building when the public school fire drill bell rang. After the school closed, it was used as a community building.

Eight

Riverton, Farragut
River Towns

The land of Riverton was originally in Missouri until the southern boundary of Fremont County was permanently moved to its current position. The town of Riverton began in the spring of 1870. A.B. Smith purchased 500 acres to create the town. The first streets were laid out by Morris Smith plowing furrows.

The following excerpt from the 50-year history of Riverton in 1910 provides insight into the early years: "Dame Nature has graciously smiled and dealt generously with the good people, who for the last fifty years have come and gone from the township. No calamities, if so they should be named, have visited during the period, except the grasshoppers of 1875, hail storm of 1883, drought of 1894 and the (craze) of '96."

In the early 1900s, the town bragged of more good roads, cement culverts, and sidewalks "than any township in Iowa for the number of people."

Farragut is situated in a lush river valley described as a beautiful prairie with wild flowers. There were several creeks in the area that joined into the Nishnabotna River. The fertile land attracted Civil War veterans from eastern Iowa. In the summer of 1870, the Missouri and Burlington Railroad was expanding from Red Oak to Hamburg. It was in the economic interest of the railroad to establish communities along the rails. In April 1868, Maj. U.D. Coy purchased a 1,700-acre farm in the area. A railroad representative, Dennison, purchased 160 acres from Coy in the spring of 1870. The railway wasted no time setting up the town. Seven weeks after the railroad started running, in September 1870, there was a plat for a town identified as Lowland, later changed to Lawrence.

Coleman Smith built the first house in Riverton in 1859. Ten years later, railroad men visited him to discuss building a railway. In an attempt to bargain, they asked for monetary consideration, saying that Sidney would provide financial backing. Smith held firm at $50 an acre for the right-of-way. The Smith property was chosen at the price quoted. The town did not rest easy until the deal was completed.

The Riverton Train Depot, completed in 1870, was built by Irish immigrants. These men brought their families and cows and camped near the site. The railroad helped Riverton become an important commercial site for the county. Because Sidney lost the railroad, mail and passengers delivered to Riverton were hauled to Sidney. First, horses and, later, Model T Fords carried the goods to Sidney.

Clay was a common material in the banks of creeks. This led to several brickyards scattered throughout the county. The one in Riverton was bought in 1881 by John Johnson after he emigrated from Denmark. He and his brother Martin made the brick used in buildings in the town, including the Riverton Baptist Church. He went to Tabor and made bricks by hand for one of the college buildings.

T. Wheeler and employees are pictured at his implement business. In 1885, the building was a hardware store and one of only a few two-story structures in Riverton. He kept a red wagon in front of the store for advertisement. Once, some oung men, as a Halloween prank, took the wagon apart. They put it back together on the roof. Everyone, including Wheeler, enjoyed the joke.

In 1874, the second school for the town was built. The structure was built of bricks made at the Johnson Brickyard. It was two stories high with three rooms. As the population grew, an L-shaped structure was added to the lower floor. The first principal was an army captain in the Civil War, T.J.R. Perry. He served the school district for almost 30 years. In 1881, the town had 194 school-age children, and 181 were enrolled. The final school building was built in 1912. It served the community as a high school until 1963. There were 51 graduating classes. Most of the classes had between 15 and 23 graduates.

Thsi picture, with a house in the foreground, was taken in the 1870s and shows a panoramic view of Riverton. The photographer is north of the town looking to the south and the rise where Riverton was built. The successful railroad operation resulted in a constantly changing landscape plagued by numerous fires that destroyed businesses.

From 1890 to 1910, Riverton reached its maximum in businesses. In 1900, there were 16 general enterprises selling everything from harnesses to dry goods. One could eat at two different restaurants, and travelers had their choice of two hotels. All services were available, including the central office for telephone calls.

This picture shows Polk Wells in his prison stripes. Wells robbed the Riverton bank on July 11, 1881. A Mr. Thomas, a Riverton merchant, shot Wells in the knee as he escaped. Wells was subsequently arrested and convicted. Upon going to prison, Wells gifted his captors with such things as a handmade leather bridle. The rumor persists but was never proven that Jesse James was involved.

The Riverton Chautauqua Pavilion is one of three such structures left in the United States. It was built in the late 1890s for an Old Soldiers Reunion. There was a rush to complete the structure so William Jennings Bryan could speak. His speech attracted the largest crowd ever in Riverton, and demonstrations were set off, including women carrying brooms and calling for a "Clean Sweep in Washington, DC." Around the turn of the century, the building was used for talent shows. Riverton talent was considered above average, and the town's productions drew appreciative audiences. At one time, the community boasted a literary society, and many lively debates were argued. One was a debate by the Iowa Farm Bureau about "What is more useful to the farmer, a tractor or a car?" The car side won.

Maxey Drug Store was one of the final drugstores in Riverton. Students who were in the last graduating classes have fond memories of the soda fountain. After school or ball games, a cherry-flavored Coca-Cola was what a thirsty teen needed. There was no worry about forgetting cash or being temporarily strapped for money. The store would run a tab. With a cherry cola costing 5¢ a glass, it took a long time to run up a 35¢ tab.

In 1875, the Chicago, Burlington & Quincy Railroad purchased the railroad in Farragut. The depot built in 1900 replaced the boxcar that had served as the station. Farragut was one of the best shipping points in the whole system. Stock, grains, and passengers helped create the constant growth of the railroad system. In the 1930s, there were six trains daily: four passenger and two freight trains.

A train station required an elevator to handle grains. The history of elevators in Farragut is one of increasing capacity. The elevator shown here in 1912 was built in 1878 to replace scooping the grain into train cars. Its capacity was 32,000 bushels. In the 1920s, it was replaced with an elevator that had a capacity of 40,000. The elevator built in 1963 has a capacity of 600,000 bushels.

This photograph, taken sometime around 1900, shows the layout of Farragut in relation to the railroad. Other towns in the county built on one side or the other of the railroad. In Farragut, the train went through the central part of town. Passengers getting off the train had only a short distance to walk into town. The image also shows the flatness of the prairie area.

Maj. U.D. Coy settled the area north of Farragut. He was well respected by town residents—so much so that they at one time suggested the town be named Coyville. He declined and suggested Farragut as the name. He selected it because he was an admirer of Adm. David Glasgow Farragut. The town supported the suggested name, and it became official in 1872. The streets of the town were named after men and events in Farragut's career. Fred Campbell was a silent benefactor to the town and townsmen. In 1956, he paid to have blue street signs with white letters erected for the town.

One of the oldest business names in Farragut is Campbell. From 1882 until 1964, the Campbell family operated a business in the town. They survived through all kinds of hardships: weather disasters ruining crops, the financial crisis in the 1930s, and a fire destroying their building in 1899. The Campbells operated a hardware and furniture store along with running a mortuary. Their first business was named A. Campbell, then A. Campbell & Sons, then Campbell's Sons & Bickett. The family business ended in 1964 when Keith Bickett became the owner. The photograph above shows the store in the early 1900s; the photograph below was taken in the 1940s. The front changed but not the location.

Another famous business in Farragut was the Replogle Roller Mill. The Replogle family had mills throughout southwest Iowa. The first mill was built in 1875, one mile from town. The second mill (shown in this photograph) was in town. Reputed to be the best mill in the area, it attracted people from as far as 30 miles away, who camped while waiting their turns. Its capacity was 85 barrels of flour, two tons of meal, and two tons of feed per day.

This picture is one of the most reproduced in Farragut. It shows the town, with its dirt street, rebuilding after the fire in 1899 destroyed many of the wooden buildings. All of the buildings on the west were destroyed and all of the fronts on the east were damaged. Town merchants quickly began to reconstruct brick buildings, with many being two stories.

Farragut built a school in the 1880s (pictured) that served the community until a school was built in 1929. High school diplomas were attainable from Farragut beginning in 1890. The town took pride in having a local woman as the superintendent during World War I. In 2010, Farragut is one of the few remaining K–12 systems in the county.

Farragut supported a full range of businesses in a prosperous farming area. In 1900, a special edition newspaper quoted another evidence of prosperity: there was not a vacant space in town for any kind of business. This street scene in the 1930s indicates the prosperity that continued for several decades.

Church services started in the railroad depot. The earliest congregations with buildings were the First Christian, Methodist, and Congregational churches. The first church building constructed was the Methodist Episcopal church. At the dedication on June 23, 1878, the board announced the cost of the church was $2,100, and funds were short by $585. At the end of the service, $592 had been pledged.

Farragut barber Herschel Whitehill, seen here with an unidentified customer, was an institution in Farragut. He started as an apprentice with Bert Kimsey, who barbered in Farragut in the early 1900s. Eventually, he had his own business and became "the" barber in Farragut. He took customer service seriously; during harvest and planting time, he stayed open late to accommodate farmers. His business was always the place to catch up on all the local happenings.

Nine

PLACES
THERE USED TO BE A PLACE CALLED . . .

This chapter is about places that used to be. Mentions of some 26 places "that used to be" have been found; some with stories, some with stories and pictures, and some with just a legal description to show that they really did exist. But all these places served a need at that time and have a real place in Fremont County's history. Some were post offices in a family homes, steamboat landings, or stagecoach stops. Some disappeared with a name change, merged into nearby communities, were bypassed by the railroad, or just dwindled away with the coming of the automobile age and easy access to larger communities. As with all early histories, there are differences of opinion as to the actual dates that events occurred. The author has tried to be as accurate as possible.

Pinpointed on the Fremont County Township Map on the next page are all of the settlements and towns ever established in the county. The following are towns for which photographs could not be found: Buchanan in Scott Township had a post office from 1856 to 1861 that replaced the Osage Post Office that operated from 1851 to 1856. Civil Bend was a steamboat landing on the Missouri River in Benton Township in the early 1840s. Cora in Walnut Township was a post office from 1855 to 1866 and became Walnut Creek Post Office in 1869. Dawsonburg in Green Township was a post office from 1851 to 1858. Eureka, a stagecoach stop in Benton Township in 1857, was gone by 1881 except for its school. Farmer City in Monroe Township was laid out in 1876 and had a post office from 1878 to 1900. Lawrence in Fisher Township was a post office site in 1871. McKissick's Grove in Madison Township was a farm neighborhood with a post office from 1849 to 1868. Summit Station in Monroe Township had a post office called Nuda from 1884 to 1886. Vaughn in Walnut Township had a post office from 1873 to 1875.

TOWNSHIP CODE

*Buchanan	*TABOR	*Deer Creek *RANDOLPH	*IMOGENE
*Osage *Bartlett SCOTT *McPaul *THURMAN	*Dawsonburg GREEN	RIVERSIDE	MONROE *Summit/Nuda *Farmer City
*Eureka *PERCIVAL BENTON *Civil Bend *Eastport	*Anderson SIDNEY *SIDNEY *Knox	PRAIRIE *RIVERTON RIVERTON	*Vaughn *Cora/Walnut Creek WALNUT *Manti *Lawrence *FARRAGUT FISHER
	WASHINGTON *Austin *Payne Jct. *HAMBURG	MADISON *McKissick's Grove	*HighCreek LOCUST GROVE *Walkerville

This map of Fremont County shows the approximate locations of each community past and present. Settlement along both the western and eastern borders was heavy. The three townships of Washington, Sidney, and Green are where the Loess Hills impacted settlement.

Begun in 1878 when the railroad came from Creston, the town of Anderson, at its peak in 1916, had 14 businesses plus two elevators and a stockyard. It was called Shiloh, which changed in 1879 to Anderson in honor of Maj. Albert R. Anderson, a representative of Fremont County who championed railroads. Thousands of head of cattle and hogs were loaded on the trains from the Anderson stockyards; the cattle were shipped to Chicago and the hogs to St. Louis. This photograph shows Sam and Will Chambers working in their Chamber Brothers Store.

Henry Phelps, owner, filed a plat for a town in 1866 and named it Bartlett, for his wife, Annie Bartlett Phelps. Many of the original settlers were Mormon, thus one of the two churches was Mormon. With daily train service by 1874, Bartlett had a post office and 10 businesses including a hotel. Pictured above is the main street of Bartlett in 1925 when the town was at its peak. The store to the left is the L and R Cash Hopkins Store, then, to the right, Bartlett Bank, the general store, and Charles Harris and Alex Thornton's lumberyard to the far right. In 1920, four country schools merged into Bartlett, and a new school was erected. The highlight for Bartlett was when Warren Harding stopped at the school while campaigning for the national presidency. He told the students they were meeting the next president of the United States.

The settlement of Eastport, also called East Nebraska City, was settled in 1858 near the Missouri River close to the Highway 2 river bridge. In the early years, border outlaws often used the town as their headquarters. The post office was established in 1865, and the town was laid out in 1870. By 1884, it boasted nine businesses, a Western Union station, and a weekly newspaper. The country schoolhouse, which was one of the last, instructed students in the mid-1900s when this photograph was taken. The students are unidentified.

Part of Locust Grove Township, High Creek had a post office from 1871 to 1900. The post office was always located in the home of the current postmaster. There were four postmasters, therefore there were four different locations for the post office. Businesses here were a blacksmith and a cheese factory. Shown is the High Creek General Store owned by Tollman and Jacobson.

121

Maj. Stephen Cooper was a trader who moved into the Knox area in 1836 when the land was part of Holt County, Missouri. He left in 1842 to join John C. Fremont's expedition to the West. Cooper sold his land, trading post, and house to Capt. John Whitehead. In 1849, the Missouri border was moved 10 miles south of Knox. Realizing he could no longer hold slaves, Whitehead sold his land to Rev. William Rector, who sold it to James and Austin Knox. James Knox operated the store and in 1884 applied for a post office permit. The town had been known as Lick Skillet and Tattle Town, but the permit came back addressed to James Knox, Knox, Iowa, thus it became Knox. This map, hand drawn by H.Y. Birkby in 1960 when he was 75 years old, shows Knox as he remembered it looking in 1900. Birkby, son of Fremont County settlers Thomas and Mary Rachel Courtney, was born in 1885 on the farm where his son Jerry and wife JoAnn live in 2011.

By 1889, Knox was known as a shipping point and bank location with daily stagecoach service to Sidney and Thurman. It had a postmaster, a general store owner and carpenter, a blacksmith, and a wagon maker. Two years later, it added a hotel plus a barber, drayman, shoemaker, brick mason, undertaker, and physician. When the second general store opened that year, one man said that now he would have to make two trips to Knox to hear all the news.

Knox grew to be a bustling pioneer crossroads. On the top of the bluff to the right is Grandview Cemetery. To the lower right is the Knox Church, and in the center is a family-oriented store that served town and country residents.

Alpheus Cutler, a high-ranking member of the Church of Jesus Christ of Latter Day Saints, was excommunicated from the church. He had a following, the Cutlerites, of 40 families comprising approximately 360 people. In 1852, this group settled in the lower East Nishnabotna River Valley of southwest Iowa. There they founded a settlement, which they named Manti, a place identified in the Book of Mormon. At its peak, Manti had a population of approximately 1,000 and a main street with 12 businesses. When the railroad was built four miles north and east of Manti, houses and businesses was literally moved to the new town of Shenandoah. Additionally, the influx of non-Mormons following the Civil War led the Cutlerites to move to different locations. In 2010, it was said there were only 12 Cutlerites remaining. Manti survived for only 25 years. All that remained of the settlement in 2011 were the cemetery with Cutler's gravestone, his house, a schoolhouse, and a grove of trees. Additionally, the stagecoach station shown here is now a private residence. The individuals in the photograph are unidentified. (Courtesy the Collection of Greater Shenandoah Historical Museum.)

McPaul was founded by James McFarland Paul of Thurman. Its post office was established in 1870 and closed in 1957. In 1895, the population was 75, and the town had a grocery store, general store, and blacksmith. The train depot was a busy place. The arrival of mail, passengers, and store orders were a daily event. There were livestock yards where cattle and hogs were kept for shipping; cattle were sent to Chicago, and the hogs went to St. Joseph. Main Street in McPaul shows the train depot and the stage (actually an old trolley) that arrived twice daily from Thurman. The fare was 25¢ each way. Constant flooding made the scene below an all-too-common site as men try to save the community from flooding.

This once-thriving town with a main street and train depot was originally called Nebraska City Junction and later was named Payne Junction in honor of Moses U. Payne. Payne owned more than 14,000 acres in this area that he divided into farms and rented. Fremont County became his permanent home in the 1860s. Following the Emancipation Proclamation by Pres. Abraham Lincoln, Payne returned to Missouri, gathered his slaves together, and explained he was moving north, and they could all go with him. More than 100 slaves that he had purchased in New Orleans accompanied him to Iowa where they became free men and women. Some became close friends, and some adopted the Payne name. A Methodist minister for more than 40 years, Payne was interested in education and supported several colleges. His business sense and religious lifestyle earned him the nickname "the millionaire minister." The Payne Post Office was established in June 1884 and discontinued in August 1955. The last gasp of this once-prosperous town came when the train depot burned sometime in the late 1950s.

Settlers located in Walkerville, in the southeast corner of Locust Grove Township on the boundary line between Fremont and Page Counties. The town was laid out in 1874 with the post office opening in 1881 and operating until 1910. Walkerville had several businesses including a tavern, dry goods store, drugstore, two blacksmith shops, a broom factory, shoe and boot shop, paint shop, millinery shop, and carpet weaving shop. It also had two physicians.

www.arcadiapublishing.com

MAP SEARCH

Discover books about the town where you grew up, the cities where your friends and families live, the town where your parents met, or even that retirement spot you've been dreaming about. Our Web site provides history lovers with exclusive deals, advanced notification about new titles, e-mail alerts of author events, and much more.

MADE IN THE USA

Arcadia Publishing, the leading local history publisher in the United States, is committed to making history accessible and meaningful through publishing books that celebrate and preserve the heritage of America's people and places. Consistent with our mission to preserve history on a local level, this book was printed in South Carolina on American-made paper and manufactured entirely in the United States.

This book carries the accredited Forest Stewardship Council (FSC) label and is printed on 100 percent FSC-certified paper. Products carrying the FSC label are independently certified to assure consumers that they come from forests that are managed to meet the social, economic, and ecological needs of present and future generations.

FSC
Mixed Sources
Product group from well-managed forests and other controlled sources

Cert no. SW-COC-001530
www.fsc.org
© 1996 Forest Stewardship Council

Find Your Place in History.